Presented to:

From:

Date:

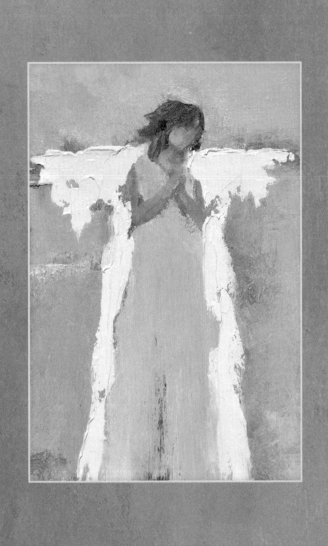

ANNE NEILSON'S

Angels

GUIDED JOURNAL

An Interactive Journey to
Encourage, Refresh, and *Inspire*

ANNE NEILSON

THOMAS NELSON
Since 1798

Anne Neilson's Angels Guided Journal

© 2022 by Anne Neilson

Published in Nashville, Tennessee, by Thomas Nelson. Thomas Nelson is a registered trademark of HarperCollins Christian Publishing, Inc.

Thomas Nelson titles may be purchased in bulk for educational, business, fund-raising, or sales promotional use. For information, please email SpecialMarkets@ThomasNelson.com.

Unless otherwise noted, Scripture quotations are taken from the Holy Bible, New International Version®, NIV®. Copyright © 1973, 1978, 1984, 2011 by Biblica, Inc.® Used by permission of Zondervan. All rights reserved worldwide. www.zondervan.com. The "NIV" and "New International Version" are trademarks registered in the United States Patent and Trademark Office by Biblica, Inc.®

Scripture quotations marked CEV are taken from The Holy Bible, Contemporary English Version. Copyright © 1991, 1992, 1995 by American Bible Society. Used by permission.

Scripture quotations marked ESV are taken from the ESV® Bible (The Holy Bible, English Standard Version®). Copyright © 2001 by Crossway, a publishing ministry of Good News Publishers. Used by permission. All rights reserved.

Scripture quotations marked ISV are taken from *The Holy Bible: International Standard Version*. Release 2.0, Build 2015.02.09. Copyright © 1995–2014 by ISV Foundation. All rights reserved internationally. Used by permission of Davidson Press, LLC.

Scripture quotations marked NASB are taken from the New American Standard Bible® (NASB). Copyright © 1960, 1962, 1963, 1968, 1971, 1972, 1973, 1975, 1977, 1995, 2020 by The Lockman Foundation. Used by permission. www.Lockman.org

Scripture quotations marked NKJV are taken from the New King James Version®. © 1982 by Thomas Nelson. Used by permission. All rights reserved.

Scripture quotations marked NLT are taken from the *Holy Bible*, New Living Translation. Copyright © 1996, 2004, 2015 by Tyndale House Foundation. Used by permission of Tyndale House Ministries, Carol Stream, Illinois, 60188. All rights reserved.

Any internet addresses, phone numbers, or company or product information printed in this book are offered as a resource and are not intended in any way to be or to imply an endorsement by Thomas Nelson, nor does Thomas Nelson vouch for the existence, content, or services of these sites, phone numbers, companies, or products beyond the life of this book.

Art direction: Sabryna Lugge
Interior design: Emily Ghattas

ISBN: 978-1-4002-3571-1 (HC)

Printed in India

22 23 24 25 26 REP 10 9 8 7 6 5 4 3 2 1

I'm grateful for the journey.
This guided journal is dedicated to my precious
family—Clark, Blakely, Catherine, Taylor, and
Ford. Along the journey of your lives, I pray that each
of you will grab ahold of the tools that will guide you
always—God's unfailing Word, His truth, and His
promises! I love you more than you will ever know.

Contents

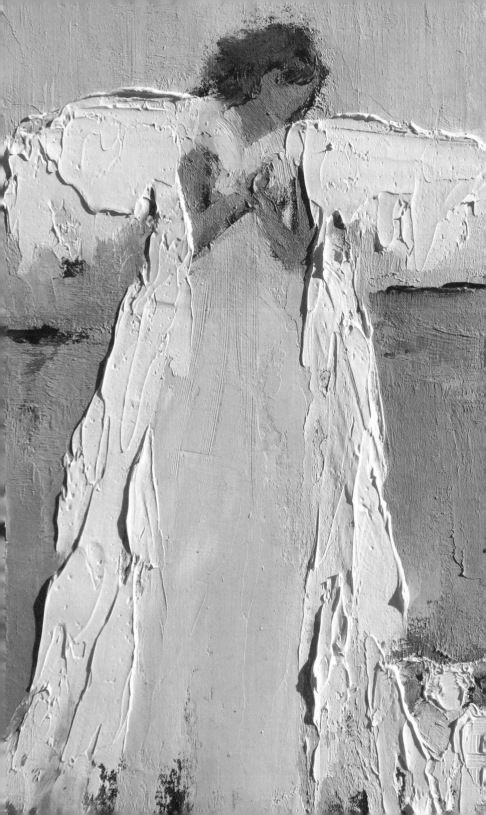

Introduction

I remember like it was yesterday—reading my first guided journal. In the year 2000 a friend had given me a hardback book, *Give Me 40 Days* by Freeda Bowers. I poured out my heart and soul onto those pages over the following forty days: sharing my deepest desires and my hardest prayers, scribbling confessions of where I had fallen short, always being guided by prompts of questioning and reflection. This process of using a guided journal took my faith to a new level. I purchased several copies for friends and even shared one with my husband, who dug in and started his own journey of reflection and prayer.

I love to journal, and tucked away in (or come to think of it, scattered around) the house are all my journals—some filled from beginning to end and some started but left behind with blank pages midway through. I wouldn't say that I am the most consistent, faithful person when it comes to journaling, but I *am* one who loves to write my "love letters" to God (always starting with "Dear Abba Father") and pour my heart and soul out to the One who sees me and who knows my innermost being.

> **WRITING MY REQUESTS, MY CRIES, MY PRAYERS, MY STRUGGLES, AND EVEN MY PRAISES ALLOWS ME TO GO BACK AND SEE THE HAND OF GOD MOVING IN MY LIFE.**

For me, it takes discipline to carve out time during my busy day, to open the blank pages and allow the quietness of my soul to emerge onto each page. Journaling is a great reminder of all the ways God has shown up in my life. I wish I had a great memory; these days I tend to forget what I had for breakfast! But writing my requests, my cries, my prayers, my struggles, and even my praises allows me to go back and see the hand of God moving in my life, in my marriage, in my children's lives, in my business, and in my relationships. It could be something like a large aha moment or simply a reminder that He knows me and sees me. The ink on the pages is the constant tribute to His promises and His presence in my day-to-day life.

When my book *Anne Neilson's Angels: Devotions and Art to Encourage, Refresh, and Inspire* came out in 2021, I had no idea we would sell over sixty-five thousand copies in just a few short months. The impact of that little devotional on readers made me pause and sit with God and just say, "Thank You." Thank You for taking the desires of my heart through art and words and fulfilling Your promises along this journey.

My publisher and I thought the perfect companion to *Angels* would be a guided journal to help you dig a little deeper along your own journey. Whether you are a young mom who is trying to find those few moments of peace and quiet during the busy days of carpool, sports, homework, and picking up toys, or you are well

past those years and going through some rough terrain—wherever you are in the footprints of life, I pray this book will help you dig deeper into your soul and see how God's mighty hand will always (not just sometimes) guide you on the journey of life.

There is always a fear of pouring out your heart on pages. Perhaps you've heard the saying, "Now I lay me down to sleep . . . If I should die before I wake, please toss all personal journals in the lake!" There is something intimate and personal about sharing the depths of our souls, our hurts and pains, our joys and praises. But I also believe that when we are truly transparent with others, that transparency draws us closer. There is a lot of power in journaling.

We serve a God whose number one desire is to be in an intimate relationship with you and with me. He already knows our innermost selves. I believe He so desires for each of us to discover our innermost being and pour it out to Him, trusting Him for all things. That is true intimacy (Into Me You See). That is what God wants from us: transparent intimacy.

Are you ready to take the journey? If you are reading this, I believe you are. I challenge you to set aside some quiet time each day for forty days to spend with Jesus and allow Him to whisper to you, to challenge you, to heal any broken areas, and to equip and empower you along your journey. Take His hand. Trust Him along the process.

I will leave you to pore over the words in Psalm 139. Don't just read them; let them sink deep, deep down into your heart and soul. Allow the Holy Spirit to move in all the areas of your life as you start this journey with your own personal *Angels Guided Journal*. As you are blessed along the way, share your journey with others!

Blessings,
Anne

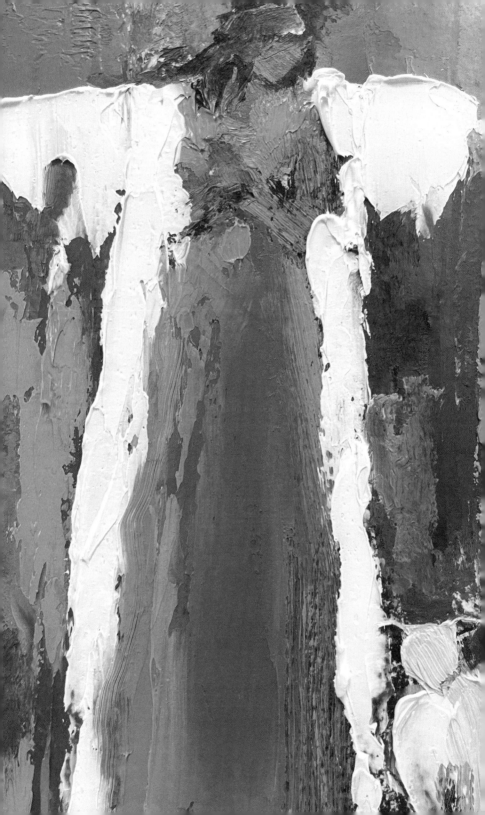

Psalm 139

You have searched me, LORD,
 and you know me.
 You know when I sit and when I rise;
 you perceive my thoughts from afar.
You discern my going out and my lying down;
 you are familiar with all my ways.
Before a word is on my tongue
 you, LORD, know it completely.
You hem me in behind and before,
 and you lay your hand upon me.
Such knowledge is too wonderful for me,
 too lofty for me to attain.
Where can I go from your Spirit?
 Where can I flee from your presence?
If I go up to the heavens, you are there;
 if I make my bed in the depths, you are there.
If I rise on the wings of the dawn,
 if I settle on the far side of the sea,
even there your hand will guide me,
 your right hand will hold me fast.
If I say, "Surely the darkness will hide me
 and the light become night around me,"
 even the darkness will not be dark to you;
 the night will shine like the day,
 for darkness is as light to you.

For you created my inmost being;
 you knit me together in my mother's womb.

I praise you because I am fearfully and
 wonderfully made;
 your works are wonderful,
 I know that full well.
My frame was not hidden from you
 when I was made in the secret place,
 when I was woven together in the depths of
 the earth.
Your eyes saw my unformed body;
 all the days ordained for me were written in
 your book
 before one of them came to be.
How precious to me are your thoughts, God!
 How vast is the sum of them!
Were I to count them,
 they would outnumber the grains of sand—
 when I awake, I am still with you.

If only you, God, would slay the wicked!
 Away from me, you who are bloodthirsty!
They speak of you with evil intent;
 your adversaries misuse your name.
Do I not hate those who hate you, LORD,
 and abhor those who are in rebellion
 against you?
I have nothing but hatred for them;
 I count them my enemies.
Search me, God, and know my heart;
 test me and know my anxious thoughts.
See if there is any offensive way in me,
and lead me in the way everlasting.

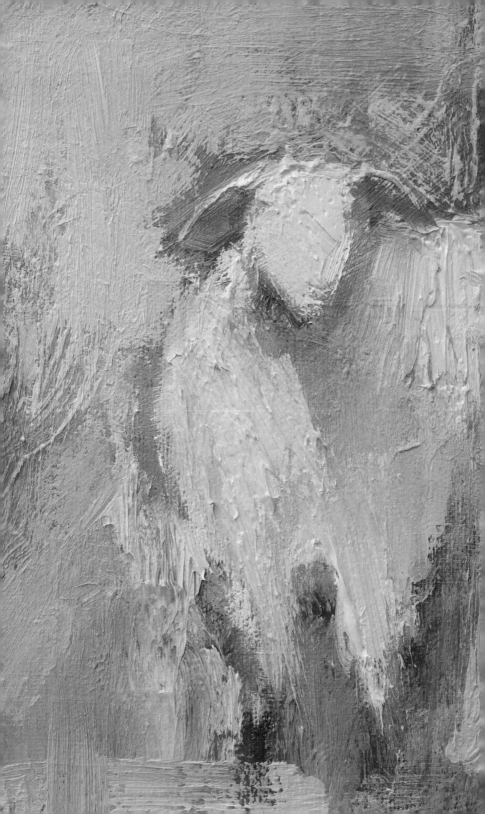

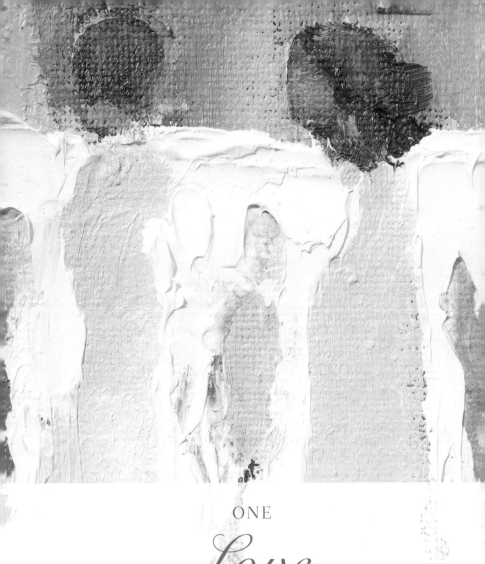

ONE

Love

We love because he first loved us.

1 JOHN 4:19

L ove is a powerful, mighty word that's often confusing and overused. Whenever I'm feeling unloved or (dare I admit) even withholding love in the midst of a disagreement or argument, I reflect on 1 John 4:7–8, and I feel my restless soul soften: "Let us love one another, for love comes from God. . . . God is love." And because God is love, there is literally nothing we can do that would make us unlovable—no matter what. Christ envelops each of us with His loving embrace, full of grace and mercy, and gently reminds us that He loves us and created us to do the same.

What does love mean to you? How do you define it?

Who in your life have you been waiting to love you first before you express love to them? Why?

GOD IS LOVE.

How might your life be different if you were the one to show love first—no matter what?

List the first five people who come to your mind in this moment. How can you express loving-kindness to them today?

1. _____

2. _____

3. _____

4. _____

5. _____

TWO

Life

*As water reflects the face, so one's
life reflects the heart.*

PROVERBS 27:19

I feel honored to have witnessed both births and deaths and to have experienced all the emotions that accompany these truly awe-inspiring bookends of life. Whether a new baby has been born or a loved one has passed away, these sacred moments should be a time of celebration, either of a life yet to unfold or of a life lived well. Life is short and often unpredictable. And while I would never want to minimize the grief or sadness that accompanies loss, I invite you to daily fix your eyes on Jesus and the gift of life. Your life is precious and worth celebrating.

Journal about the areas in your life where you have been feeling a little lifeless.

List some ways you can live life to the fullest.

1. _____

2. _____

3. _____

4. _____

5. _____

I love Psalm 37:4, which says, "Delight yourself in the
LORD, and he will give you the desires of your heart" (ESV).
What are the desires of your heart?

Life is meant to be fully lived and celebrated. What is one thing you are grateful for, and how could you celebrate this in your life today?

YOUR LIFE IS PRECIOUS AND WORTH CELEBRATING.

THREE

Gift

*"You are the light of the world. . . . Let your light
shine before others, that they may see your good
deeds and glorify your Father in heaven."*
MATTHEW 5:14, 16

I've been called by God to many different roles in my life, and I am grateful for every role in every unique season. Each of us has a set of roles to play in the world, and each has been given gifts that allow us to step into these special positions. If you're feeling overwhelmed by life and unsure about what to do next, I invite you to pause and reflect for a moment on the gifts and strengths God has given you so you can be uniquely prepared for your purpose and mission in this season.

As you think of the times when you feel most fulfilled, what kinds of activities are you doing?

Who are you with?

Where are you?

What gifts are you using during these times?

List all the roles you play in life. What new roles or positions do you feel you are being called to participate in?

Current Roles	New Roles

What old roles are you still involved in that you might need to let go of?

1. _____

2. _____

3. _____

4. _____

5. _____

You are not meant to hide your light. It's time to shine! Is there something in your life that has you feeling overwhelmed, stuck, or just unable to shine? How can you use your strengths and talents at this time?

I INVITE YOU TO PAUSE AND REFLECT FOR A MOMENT ON THE GIFTS AND STRENGTHS GOD HAS GIVEN YOU.

FOUR

Joy

Splendor and majesty are before him;
strength and joy are in his dwelling place.

1 CHRONICLES 16:27

My kids wouldn't necessarily describe me as joyful. They'd tell you I'm often too busy worrying and enforcing rules to focus on joy and fun and happiness. As a result, I've spent a lot of time with God, asking Him to fill me with joy—the kind that comes from Him and the kind no one can steal, regardless of my circumstances . . . because joy and fun and happiness aren't the same things, are they? Happiness and fun are conditional, based on the circumstances of the moment, whereas joy is rooted in our identities in Christ. I might not always be fun or happy, but I'm dedicated to being joyful. I've learned how to wake up each day and claim joy—joy in Him, joy in a new day, and joy in a fresh opportunity to live out His purpose for my life.

Faith and joy go hand in hand. It's comforting to know that no matter the challenges or darkness we're facing, "joy comes in the morning" (Psalm 30:5 NKJV). What challenges are you facing right now where you can already see God's hand at work?

Look up several Bible verses on joy. Which ones speak to you? List the Scripture references here as a place to help remind you to claim joy in Him.

Think of a few things that always bring you joy. What are these joy triggers that you can use to remind you of the spiritual joy that's always available?

1. _____

2. _____

3. _____

4. _____

5. _____

As you think about the day or week ahead, what activities or commitments are you not looking forward to? How can you choose to bring joy to each of those situations?

WAKE UP EACH DAY AND CLAIM JOY.

How will you wake up tomorrow and claim joy?

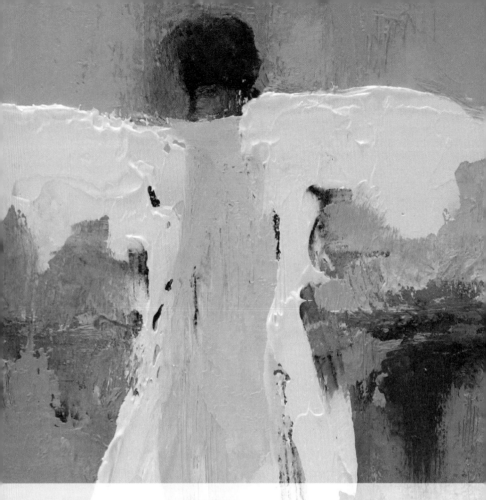

Obedience

*Do not merely listen to the word, and so
deceive yourselves. Do what it says.*
JAMES 1:22

One of my favorite lessons to teach children is about the condition of our hearts and the junk that can collect there. We discuss things that might disappoint God—things like lying, cheating, and fighting—write them on slips of paper, and then place them inside a beautifully painted bowl. In a matter of minutes, the beauty inside the bowl is covered over with the junk! We talk about how this impacts our hearts and our relationship with God. Then we memorize Psalm 51:10 and pray for God to restore our hearts. This activity is a reminder that He'll do the heavy lifting to clean our hearts, but it does require daily obedience on our part.

The idea of obedience can trigger all sorts of meanings and feelings for people. What does obedience mean to you? Do you have a positive or negative association with it?

Think of one area of your life where you feel it's most natural for you to be obedient or disciplined. Can you see the benefits that this discipline provides? List them below.

1. _____

2. _____

3. _____

4. _____

5. _____

Below, draw a picture of a heart. What's the junk that's been collecting in your heart? List or draw symbols for these things inside the heart.

Now draw an even bigger heart. List or draw symbols of the most beautiful parts of your heart—perhaps include the fruit of the Spirit—that this junk has been covering.

SIX

Wisdom

*But the wisdom that comes from heaven
is first of all pure; then peace-loving,
considerate, submissive, full of mercy
and good fruit, impartial and sincere.*

JAMES 3:17

We have the ability to ask for any gift from God, just as Solomon did, but I admit that I don't ask for wisdom as often as I could. I tend to ask for things like direction, patience, peace, or joy; wisdom isn't typically the first thing that occurs to me. It takes my intention and daily following of our Creator before I realize how much I need His wisdom. Wisdom may not seem like the most exciting thing to ask for or to go deeper into, but to me it's so beautiful. And I find that as I gain wisdom, the other things I previously asked for seem to fall into place.

When I think of wisdom, I often go to the book of Proverbs. Open this Old Testament book and see what speaks to you there. Write the verse; then meditate and pray on it and see how God is guiding you with those selections.

There's intelligence, and then there's wisdom. What are the differences to you? What makes wisdom distinct and special?

When you think of wise people, who comes to mind? Are they people in your personal life, celebrities, historical figures? Name a few of your favorites here to draw inspiration from. Why did they make your list?

Choose one of the wise people you listed and dive deeper.
If it's a person in your life, think of a past conversation with
him or her that made a difference to you. If it's a celebrity
or historical figure, do some reading and research about
that individual. What piece of this person's wisdom or
teaching stands out to you as something you needed to
hear today?

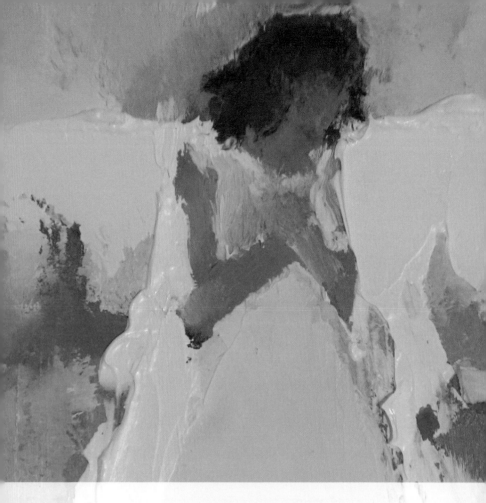

SEVEN

Habit

I can do all things through him
who strengthens me.

PHILIPPIANS 4:13 ESV

We all have habits. Some are helpful; others not so much. So I try to start my day with as many of the "good" ones as I can. My favorite is specifically carving out time to spend in God's Word. This habitual practice sets me up for my day. My other favorite is setting phone alarms that pop up with my favorite scripture during busy times of the day. No matter what circumstances I might find myself in, I have a daily reminder at 3:20 p.m., when I'm usually just about ready to call it quits, that He can "do immeasurably more than all we ask or imagine, according to his power that is at work within us" (Ephesians 3:20).

In 2 Timothy 1:7, Paul taught that "the Spirit . . . gives us power, love and self-discipline." What comes to mind when you read this?

What are some of your daily and weekly habits that really help you to be the kind of person you want to be?

1. _____

2. _____

3. _____

4. _____

5. _____

Think of a habit you'd like to break. Write this below and think of a new supportive habit you could put in its place whenever you feel triggered to engage in that habit.

Instead of _____, I'm going to

_____.

WE ALL HAVE HABITS.

There's a philosophy for creating new habits, called habit stacking, where you pair a new habit with an existing one (for example, you might floss your teeth when you brush them). What's a new Christ-centered habit you'd like to start—one that would really make a difference in your life— that you could stack or pair with an existing habit?

What kinds of reminders could you set up to help yourself remember the new habits you'd like to create? This is especially helpful with habits of mindset and the fruits of the Spirit: love, joy, peace, patience, kindness, goodness, faithfulness, gentleness, and self-control (see Galations 5:22–23 ISV).

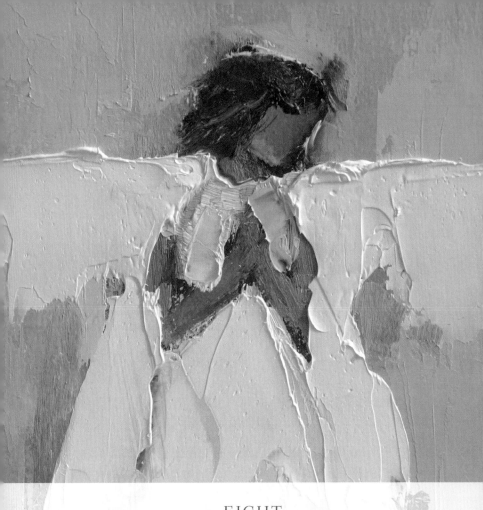

EIGHT
Guide

"My sheep listen to my voice; I know
them, and they follow me."

JOHN 10:27

I often think of God as an airplane pilot and me as a passenger along on this bumpy ride. My heavenly Father is the Captain of my life, so whenever I hit turbulence, I imagine Him saying, "This is your Captain speaking, and I'm in control." *Thank goodness!* And then I go to His Word for actual guidance. It's always there, even when I can't imagine how He is possibly going to speak to me in any given crazy circumstance. I can always trust Him. His Word and guidance never fail me. It's only me who sometimes fails to seek His guidance.

Who or where do you typically turn to for guidance?

Sometimes it's obvious and sometimes it's not, but God is always leading and guiding us. Where do you sense He is guiding and leading you?

HIS WORD AND GUIDANCE NEVER FAIL ME.

Let's make a little visual map. In the circle on the left, fill in where you are now. This could be where you are in life, geographically or spiritually. In the circle to the right, where do you see yourself going with God's leading and guidance?

How will you get there? List various ideas and steps below. Remember that God's Word is a lamp for our feet and a light for our path (Psalm 119:105), and we need to always turn to Him as our ultimate guide.

Step 1._____

Step 2._____

Step 3._____

Step 4._____

Step 5._____

Surrender

*Surrender your heart to God, turn to him in prayer, and
give up your sins—even those you do in secret. Then you
won't be ashamed; you will be confident and fearless.*

JOB 11:13-15 CEV

I'm a chronic goal setter and goal achiever, which means I get so busy and interested in planning my life that I sometimes forget to hand over the reins to God and submit to His plans. I have to remind myself often to submit to the Lord, to reposition myself into a posture of surrender to His will. Only by doing this and shedding my own plans (and letting go of my ego!) can I begin to truly explore the path God has planned uniquely for me. God's vision is so much bigger than my own, which means His plans are far greater than mine, and those are the plans I want for my life.

What does surrender feel like to you?

It's not always our plans we need to surrender. Sometimes we need to let go of our beliefs or feelings or behaviors. What are some things holding you back that you are feeling called to surrender?

Have you ever been forced to give up or surrender something? How does that compare to when you willingly offer something?

GOD'S VISION IS SO MUCH BIGGER THAN MY OWN.

Think of a time when you willingly gave up or gave in, either to God Himself or to a person. What fruit of the Spirit was revealed as a result? Describe that feeling.

TEN

Foundation

*So this is what the Sovereign LORD says: "See,
I lay a stone in Zion, a tested stone, a precious
cornerstone for a sure foundation; the one who
relies on it will never be stricken with panic."*

ISAIAH 28:16

Laying a solid foundation is the most critical part of ensuring structural integrity, whether you are building a home, a relationship, a career, a family, or anything else. Foundations are often invisible, lying deep beneath the surface. Part of laying a solid foundation requires digging and hard work and even testing for things like bad dirt. This metaphor can be carried from construction sites to life in general. I've had to clear out and dig up some of that "bad dirt" myself—things like bad habits, resentment, guilt—before a good, solid, sturdy foundation could be laid. My prayer is that we no longer hide our dirt or shy away from the digging process, but instead allow the Lord to lay a solid foundation of His love in our hearts.

Today, pray and ask God what needs to be dug up and cleared out of your life. Ask Him to show you where the cracks are in your foundation. What does His still, small voice whisper back?

In the base of the pyramid below, list some things you think are important for building a strong foundation for your personal faith.

Where do you see that your faith could use some structural integrity?

ALLOW THE LORD TO LAY A SOLID FOUNDATION OF HIS LOVE.

Are you being called to dig deeper? If so, where and how?

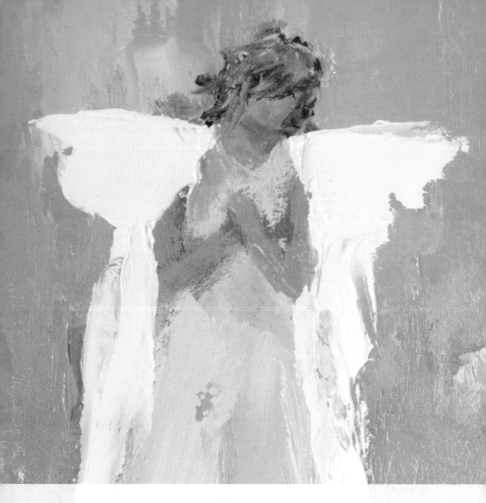

ELEVEN

Still

*The Lᴏʀᴅ will fight for you, and
you have only to be silent.*

EXODUS 14:14 ᴇꜱᴠ

The world can become really noisy at times. Whether the noise was coming from outside in a busy, bustling city or from my own internal dialogue and chatter, there have been times when I couldn't even hear myself think. I had to physically put myself in an empty room and quiet my thoughts by going to my heavenly Father in prayer. It was there that I heard His heartbeat and His comforting voice cut through the noise. Our God is so mighty a mere whisper from Him clears the chaos that disrupts our peace.

Do you have a quiet place? If so, where is this special place where you can go that's a space all your own? If not, create a sacred space today.

Are you someone who is able to be still and quiet, or do you get restless when you're not on the go? List some things that get in the way of your sitting still before the Lord.

1. _____

2. _____

3. _____

4. _____

5. _____

Today, take five minutes in perfect stillness and quiet—
or at least as quiet and still as you can find. Sit in a
comfortable position, inhale deeply, hold it for a second,
and then release it and allow your body to relax. While
trying to keep your mind quiet, think solely on your
heavenly Father, who gives you breath. Unlike a prayer,
this is more of a meditation and offering to Him. Notice
His presence all around. Describe this experience.

How can you begin to carry an inner stillness amid chaotic circumstances?

TWELVE

Fellowship

*When you assemble, each one has a psalm, has
a teaching, has a revelation, has a tongue, has an
interpretation. All things are to be done for edification.*

1 CORINTHIANS 14:26 NASB

As we've become more virtually connected through social media, I'm aware of how disconnected we've become in real life. Proverbs 27:17 tells us, "As iron sharpens iron, so one person sharpens another." This refining process happens only with direct contact, in person, as we share space and meals and stories—and perhaps as we bump elbows in a kitchen or around a table. It's how we learn and grow and nurture one another for our mutual benefit. We are designed for community, so I invite you to think of the most important people in your life and set aside time for those with whom God has entrusted you.

Think of the times when you've been the most fulfilled during periods of fellowship. List a few of these memories below.

1. _____
2. _____
3. _____
4. _____

Who are the people in your life who exemplify this refining process and provide a mutually beneficial relationship? List them below.

1. _____
2. _____
3. _____
4. _____

If you could design your ideal time of fellowship, who would be there? Where would it be? What would you be doing? Try to get as detailed as possible.

Now, what would it take for you to create that scenario?
In some cases, you may have to get creative to make it
work. Is there anything in the way for you? If so, take that
to the Father and ask Him to guide you in creating a time
of fellowship that's both honoring to Him and mutually
beneficial to all present.

Hope

*This hope is a strong and trustworthy
anchor for our souls. It leads us through the
curtain into God's inner sanctuary.*

HEBREWS 6:19 NLT

I can't talk about hope without also talking about faith. Faith is my anchor, and it's what allows me to have hope. As the tides of life ebb and flow and as my calm seas turn to choppy waters, it's hope that pulls me through every time. I have faith that I'll be able to weather whatever storm comes my way on the seas of life, and I'm therefore able to keep my hope intact—knowing that He will make everything beautiful again in its time (Ecclesiastes 3:11). Put your faith first; then hope naturally follows.

What does hope feel like to you? Does it feel like wishful thinking, or is it more of a knowing?

Have you ever lost hope? What have you hoped for that hasn't happened? How do you feel about that?

First Corinthians 13:13 tells us, "And now these three remain: faith, hope and love. But the greatest of these is love." If you're struggling in any area where you've lost hope—even a little—how can you bring more love to the situation?

PUT YOUR FAITH FIRST; THEN HOPE
NATURALLY FOLLOWS.

Let's create a visual hope chest. What hopes have you wanted to share with God? Write keywords or draw images and symbols in the box below; then offer them to your heavenly Creator.

FOURTEEN

Connect

*Then you will call upon Me and go and
pray to Me, and I will listen to you.*
JEREMIAH 29:12 NKJV

Think of the person in the world you love and adore the most. Can you imagine how exciting it would be to deeply connect with that individual every day? I don't mean just passing by or making small talk or binge-watching shows together. I mean deeply seeing, knowing, and understanding that other person and feeling known by him or her in return—and finding new ways to fall in love with that person all over again. This is how I imagine God feels about us. He wants to spend time with us each day, deeply connected, not just passing by or checking something off a list. He knows the difference. And I want to always feel that way about Him too.

Where in life are you feeling disconnected? It could be in relationships, at work, with yourself, or spiritually—list everything that comes to mind.

Are there relationships where you're afraid to connect and truly be seen? If so, share them here.

FALL IN LOVE WITH THAT PERSON ALL OVER AGAIN.

What would it take for you to bring your most authentic and transparent self to those who matter most?

Let's go deeper into connecting with God. Carve out some quality time where you can just *be* with Him. Be with Him in prayer, sharing your heart and mind and including all those places where you feel disconnected and guarded. Be with Him in praise, expressing gratitude for who He is and all He provides. Let Him really see you. (*Psst. He already does.*) Afterward, describe the heavenly experience to help anchor your faith.

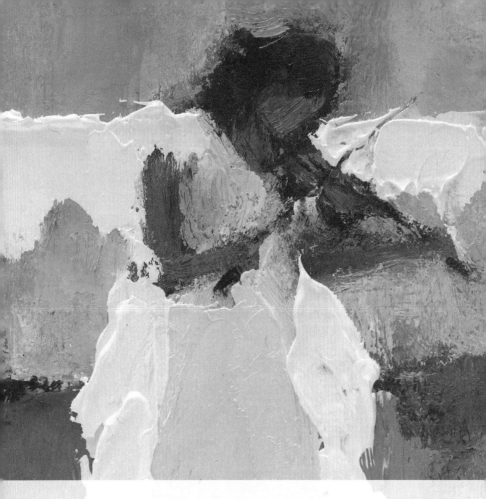

FIFTEEN

Create

*He has filled them with skill to do all kinds of
work as engravers, designers, embroiderers . . .
all of them skilled workers and designers.*

EXODUS 35:35

I've certainly let doubt creep into my heart along this journey, especially when my faith was tested. I've second-guessed myself—and even questioned God when I sensed His prompting—but eventually found my way back to creating. I became a full-time artist as I followed His leading. But it took a long time and included a few detours. As my faith continues to grow, so does my creativity. I find myself drawn even closer to our ultimate Creator and am amazed by how He instills in each of us our own unique and distinct creative expression.

Where does God's handiwork show up the most for you?

Think of all the ways creativity shows up in your life. Draw or list some examples in the space below.

If you knew you would not fail, list all the creative outlets that you would love to try—and try one!

1. _____

2. _____

3. _____

4. _____

5. _____

6. _____

7. _____

8. _____

9. _____

10. _____

How can you bring your unique expression to your daily tasks or to your work?

HE INSTILLS IN EACH OF US OUR OWN UNIQUE
AND DISTINCT CREATIVE EXPRESSION.

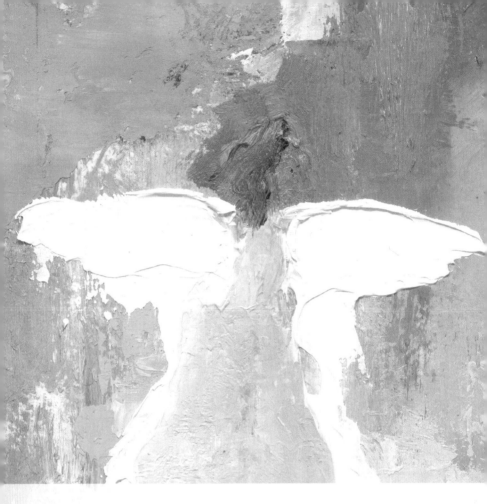

SIXTEEN

Witness

How beautiful are the feet of those
who bring good news!
ROMANS 10:15

I have felt guilty at times, unable to relate to the typical Christian witness. Depending on the setting, I can become shy or closed off, and I often prefer to fly under the radar, minding my own business. But over time, I've realized that just as we each have been given a unique personality, we also have our own distinct, beautiful, God-glorifying ways to witness. Me? I paint angels. And if you step into my gallery, I'm suddenly lit up and open and ready to share all of the amazing ways God shows up in my life. Whether it's through words or actions, or using your gifts and talents, you too have your own unique path to witness. Have you found it yet?

What does it mean to be a witness for God?

List some ways God has shown up and worked in your life. Do you regularly share these with family and friends?

What are the things that keep you from sharing your faith? This could be everything from self-talk to feelings to fears. List them below.

1. _____

2. _____

3. _____

4. _____

5. _____

6. _____

7. _____

8. _____

9. _____

10. _____

YOU TOO HAVE YOUR OWN
UNIQUE PATH TO WITNESS.

What is the one thing you know for sure about why you
believe?

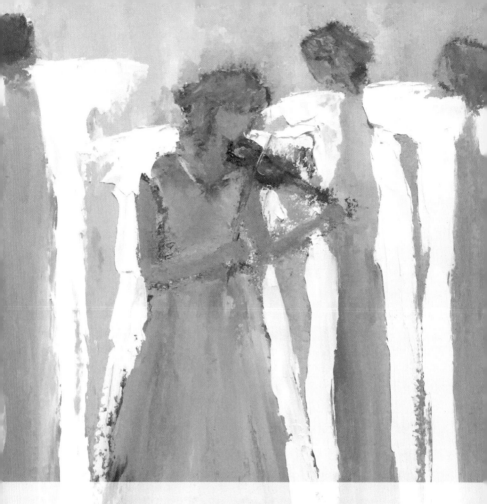

SEVENTEEN

Worship

"Worthy are you, our Lord and God, to receive glory and honor and power, for you created all things, and by your will they existed and were created."

REVELATION 4:11 ESV

My favorite way to worship is listening to praise music while painting in my studio. It's where I feel most connected to how the word *worship* is used in Romans 12:1, with the Greek word *latria*, which essentially means "adoration of God." My work is both my service and where I offer worship. It's how I thank and acknowledge Him for His perfection. And oftentimes it's the music that helps this all come through for me. This time of communion and offering praise reminds me of our heavenly Father's sovereignty, love, and wisdom, drawing me ever closer to Him.

What does the word *worship* conjure up in your heart and mind?

List all the ways you can think of to worship.

1. _____

2. _____

3. _____

4. _____

5. _____

6. _____

7. _____

8. _____

9. _____

10. _____

Psalm 96:8 tells us, "Give to the LORD the glory he deserves!" (NLT). Using examples from your own life, what glory do you see He deserves?

MY WORK IS BOTH MY SERVICE AND WHERE I OFFER WORSHIP.

Some of us worship only on Sundays. As you think about how you spend your days and weeks, what are some other opportunities where you could be offering and expressing worship?

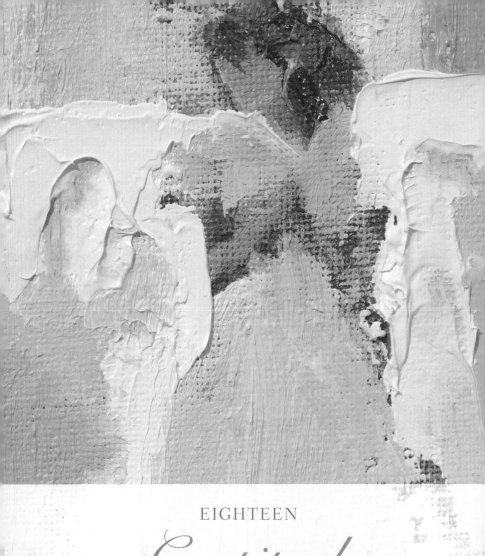

EIGHTEEN

Gratitude

Give thanks to the LORD, for he is good.
His love endures forever.

PSALM 136:1

*T*hank You. These two little words go a long way in express-
ing gratitude. It's easy to be thankful for the good stuff:
a gift, a promotion or raise, a new client referral, a sunny day.
But what about the hard stuff? What about the dreaded health
diagnosis? The child who gets in trouble at school? The argument
with your partner? It's when I express gratitude during hardships
that I grow and learn the most. "Thank You for helping my doc-
tor figure out what's wrong with me." "Thank You for bringing
my child home safely from school." "Thank You for showing me
another side to this problem with my partner."

What are the easy and obvious things you're always
thankful for?

God has provided us with so much that it's easy to take the little things for granted. List some of the things you've been taking for granted or have forgotten to be grateful for.

1. _____
2. _____
3. _____
4. _____
5. _____
6. _____
7. _____
8. _____
9. _____
10. _____

Now for the harder part: Think of all the hardships you're either going through or have gone through. What can you be grateful for in these areas?

1. _____
2. _____
3. _____
4. _____
5. _____

"THANK YOU."

Let's turn our attention to God now. How are you grateful for Him specifically? Write Him a love letter below.

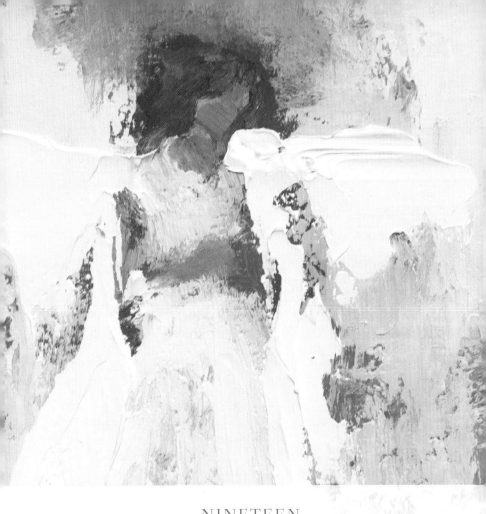

NINETEEN

Rest

*"Come to me, all of you who are
weary and carry heavy burdens,
and I will give you rest."*

MATTHEW 11:28 NLT

Have you noticed how when we think of rest we often think of sleep? They can mean the same thing, but certainly not always. You can sleep and still not feel rested. And you can fully rest without sleeping. The best way to understand this is by looking at Merriam-Webster's definition, which defines *rest* as "to be free from anxiety or disturbance."* Wow. That sounds amazing, right? To me, this type of ultimate rest is found when I go to Christ with my troubles.

How do you find rest on a daily basis?

One of my favorite ways to talk about rest is by using this acronym: *Rely. Engage. Surrender. Trust.* Take a moment to reflect on each word and think of how you can apply each in your life.

Rely: _____

Engage: _____

Surrender: _____

Trust: _____

We all have things in our lives that cause us to become weary, troubled, or disturbed. Which burdens do you need relief or freedom from?

TO ME, THIS TYPE OF ULTIMATE REST IS FOUND WHEN I GO TO CHRIST WITH MY TROUBLES.

When was the last time you felt fully rested? Think on this and journal below. Then, without falling asleep (at least not right away), spend time with God in prayer and share your burdens with Him. Let Him give you His ultimate rest.

* Merriam-Webster, s.v. "rest" (v.), accessed September 13, 2021, https://www.merriam-webster.com/dictionary/rest.

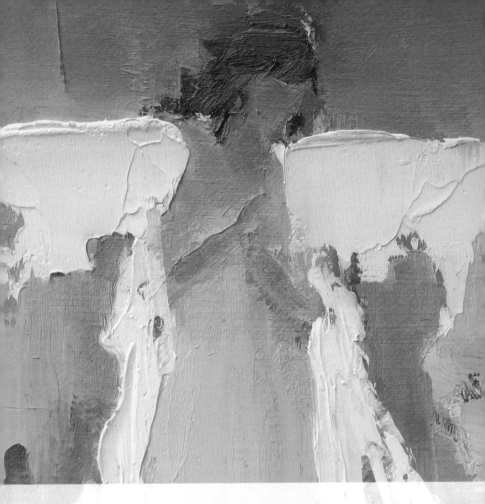

TWENTY

Assurance

*Let us draw near to God with a sincere heart
and with the full assurance that faith brings.*

HEBREWS 10:22

Our God is constant and everlasting. He never changes. We are assured of this. And it's precisely this assurance that helps me when I am reminded that my own life is ever changing, sometimes causing uneasiness and doubt to rear their ugly heads. Each day brings its own new set of shifting circumstances—everything from the weather to new tasks and projects to new people and all of *their* circumstances. So when we feel imbalanced and unsettled by change, however big or small, let us rest with assurance that God is good and true. His love for us is steadfast and unwavering.

What are you most sure of?

Think of a massive change you've gone through in your past. Looking back, which of God's promises can you see was present and steadfast all along?

Whether you're navigating brand-new, life-changing seasons or new circumstances from day to day, how can you bring the awareness and wisdom of God's assurance into times of uncertainty?

In Ecclesiastes 3, Solomon mentioned there being a season for everything under the sun. Take inventory and list where you notice the changing seasons in your own life.

1. _____

2. _____

3. _____

4. _____

5. _____

6. _____

7. _____

8. _____

9. _____

10. _____

LET US REST WITH ASSURANCE THAT
GOD IS GOOD AND TRUE.

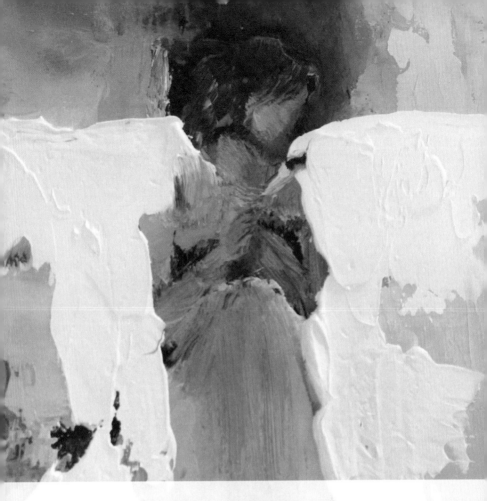

Abundance

*"I came that they may have life
and have it abundantly."*

JOHN 10:10 ESV

For me, one of the best demonstrations of abundance comes in Luke 5:5–7 when Jesus told Simon and the disciples—who had been working hard fishing all night, without catching anything—to simply switch the sides of the boat they were fishing on and let down their nets. Before they could realize what was happening, their nets were so full they were nearly breaking. The Lord had brought them precisely what they had asked for, abundantly so, yet they could barely handle it. They couldn't comprehend the abundance that God offered because they were so used to scarcity. Sometimes we forget to ask for abundance because we can't comprehend what that looks like, but God is waiting to give it to us anyway.

It's time to let down your nets. What are you asking God to fill them with?

Abundance requires readiness and integrity. In the example from Luke, the nets barely had the integrity to hold all the fish, and the men could barely manage all that was given them. How are you preparing for the abundance that Scripture promises?

> THE LORD HAD BROUGHT THEM PRECISELY WHAT THEY HAD ASKED FOR, ABUNDANTLY SO.

If the Lord chooses to multiply abundantly what you're asking for, how will you respond? In your mind, is there such a thing as *too much* of what you're asking for?

How will your life, your faith, your walk with God be different when He fills your nets? What will that make available for you?

Add Ephesians 3:20 to a phone alarm set for 3:20 p.m. so that this scripture pops up as a daily reminder: "Now to him who is able to do immeasurably more than all we ask or imagine, according to his power that is at work within us." No matter what, He is working and providing. Will you take this on?

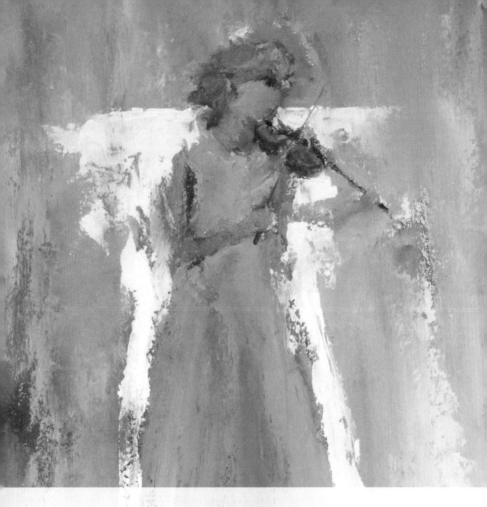

TWENTY-TWO

Strength

*"I will strengthen you and help you; I will
uphold you with my righteous right hand."*

ISAIAH 41:10

Whenever I try to do things in my own strength, I inevitably struggle. Physically, mentally, emotionally, spiritually— the struggle is real. And sometimes when I'm being particularly stubborn, trying to do something all on my own, they can all hit at once! It's only when I turn to Christ and His Word, acknowledging Him for His sovereignty, that I feel the struggle subside. In this space of admitting my own weakness, I can rely on His strength to carry me through.

What are you trying to carry and manage all in your own strength? (Hint: this is probably where you feel most exhausted by all the burdens you carry.)

Where in your life today do you need God's strong and mighty hand to help carry you?

I CAN RELY ON HIS STRENGTH
TO CARRY ME THROUGH.

In each area of life below, list some of your God-given strengths and trust Him to equip you in each of these areas.

Family: _____

Job or Career: _____

Money and Finance: _____

Faith and Spirituality: _____

Love and Romance: _____

Creativity: _____

Recreation: _____

Health: _____

Community: _____

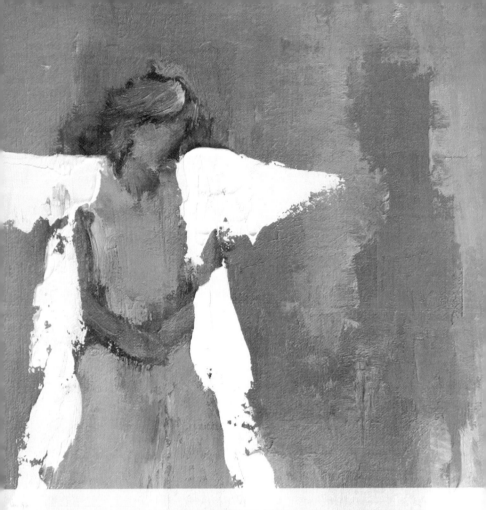

TWENTY-THREE

Provision

*"I will bless her with abundant provisions;
her poor I will satisfy with food."*

PSALM 132:15

I continue to be amazed and delighted by what God provides—to me, to my family, to my community. Sometimes it's the smallest things that I notice the most and that draw me closer to Him, reminding me that He sees me. He knows my heart. He knows how to best provide for me in any given moment on any given day. He often knows what I need before I'm aware of it myself: an unexpected hug, a shady parking space on a hot summer day, a word of encouragement, a new commission or client.

Have you ever asked God for a tangible reminder of His love and power of provision? How did He show up?

As you consider your life, list some things God has provided.

1. _____

2. _____

3. _____

4. _____

5. _____

6. _____

7. _____

8. _____

9. _____

10. _____

HE KNOWS HOW TO BEST
PROVIDE FOR ME IN ANY GIVEN
MOMENT ON ANY GIVEN DAY.

In Judges 6, Gideon tested God to gain clarity about His promise, to get direction to do His will, and, therefore, to have confidence that God would provide what he needed. In turn, God tested Gideon by asking him to abandon his great army for a small one, asking Gideon to have faith that He would provide. Where might God be stirring your heart, asking you to give up something in order to watch Him move?

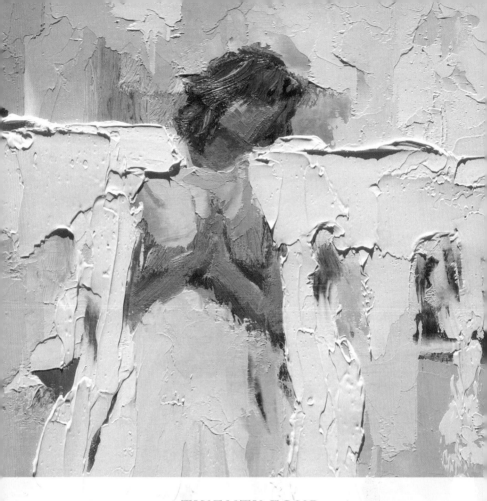

TWENTY-FOUR

Faith

*Now faith is confidence in what we hope for
and assurance about what we do not see.*

HEBREWS 11:1

I've taken literal giant leaps of faith—like skydiving out of an airplane—and I've taken baby steps of faith. Each time, I did so with the assurance that I would be okay, even when "okay" meant going through something incredibly scary and difficult. However, I've rarely taken a leap of faith without it somehow leaving its indelible mark on my life, serving as a welcome reminder of how far faith can take me. Walking in faith doesn't necessarily mean life is easy or that you won't free-fall from time to time, but walking in faith alongside our Father does mean He will catch you as you land every single time.

Have you ever had a time when someone lost faith in you? What was that like for you?

There are countless ways to express faith in our lives. How do you express it? Do you need to see before you believe, or can you "walk in faith," believing without seeing?

In Matthew 17:20, Scripture tells us: "If you have faith as small as a mustard seed, you can say to this mountain, 'Move from here to there,' and it will move. Nothing will be impossible for you." Where could you use this mustard seed type of faith right now in your life?

HE WILL CATCH YOU AS YOU LAND EVERY SINGLE TIME.

If you could have a faith-filled life, what would that look like? What might you do differently? What risks might you take? What new challenges would you accept?

TWENTY-FIVE

Touch

She came up behind him and
touched the edge of his cloak, and
immediately her bleeding stopped.

LUKE 8:44

Today's message is simple: No matter what disease of the body, mind, or spirit, I believe that if we can touch the cloak of Jesus, we can receive His supernatural healing—much like the woman in Luke 8:40–56. God is still the ultimate miracle worker, and one touch can cure and heal and restore.

What might it look like for you to "touch the cloak of Jesus" in today's world?

> ONE TOUCH FROM HIS
> MIGHTY HAND CAN CURE
> AND HEAL AND RESTORE.

Do you believe in miracles? Why or why not?

Whether or not you believe in them, do you need a miracle in your life that only God can provide? Share this below and offer this as a prayer. Be specific. Be expectant.

What fears or beliefs might you need to relinquish related to this miracle?

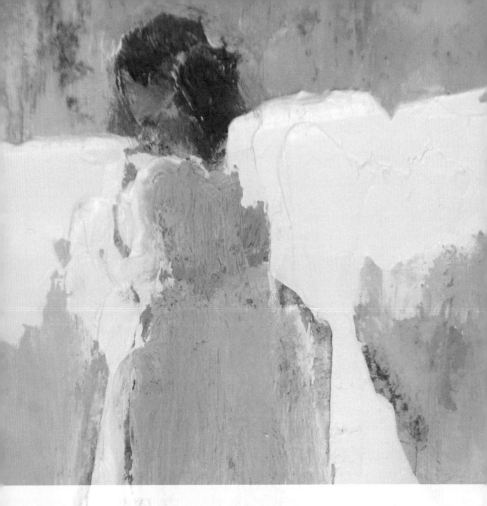

TWENTY-SIX

Patient

*Be patient, therefore, brothers, until the coming
of the Lord. See how the farmer waits for the
precious fruit of the earth, being patient about
it, until it receives the early and the late rains.*

JAMES 5:7 ESV

There's a running joke among Christians, perhaps one shrouded in wisdom, that we should never pray for patience or else the Lord will teach it to us. To pray for patience is to ask for situations in which we can learn it. Jesus taught by parables and example, and learning patience without discovering it for yourself is no different. I'm not always patient. It's been one of my biggest areas of growth, one that's required my obedience time and again, and sometimes I still don't get it right. But I haven't regretted those lessons, and I am grateful for the patience I've gained as a result.

We are always sowing seeds of some sort. What are you sowing that you might regret reaping one day?

What do you wish to reap one day? What kinds of seeds might this require?

Sometimes, simply being patient is what's required. Other times, it's God who is patiently waiting on us to be obedient in action. There's a saying that I love that suggests we are into microwaving and God is into marinating. In what areas of your life do you see God at work "marinating"?

TO PRAY FOR PATIENCE IS TO ASK TO BE GIVEN SITUATIONS IN WHICH WE CAN LEARN IT.

As you're patiently waiting, how else can you nurture and shepherd your current conditions to reap the greatest rewards? Does anything need weeding, pruning, feeding, or nourishing?

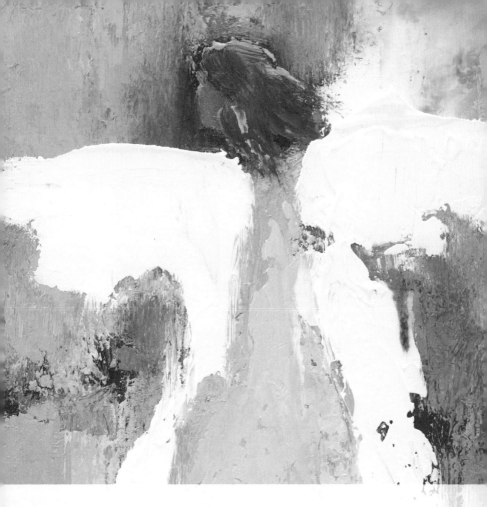

TWENTY-SEVEN

Storm

"The rain came down, the streams rose,
and the winds blew and beat against
that house; yet it did not fall, because
it had its foundation on the rock."

MATTHEW 7:25

I've seen ferocious storms show up without warning just before an important event, only to be quieted just as quickly, leaving a glorious rainbow in their place. To me, thunderstorms are a great metaphor for the kinds of trials in life that can pop up out of nowhere. Storms can leave us flooded, in the dark, without power. Sometimes it's only a storm that can slow us down or bring us to a stop. In those times, the storm itself becomes a strange harbor of sorts, a God-gifted place to rest and notice and reflect and surrender.

It's counterintuitive, perhaps, but have you noticed that when a storm occurs, sometimes it's the very thing that's somehow needed? How have you personally experienced this?

What kinds of storms or disasters have shaken up your life, and how did they turn out? Think of literal and figurative examples.

Fill in the blanks:

If _____
had never happened, I would never have experienced

as a result.

Every storm is temporary. What are some ways you can begin to prepare for future storms?

SOMETIMES IT'S ONLY A STORM
THAT CAN SLOW US DOWN
OR BRING US TO A STOP.

Use the space below to write down several Bible verses to cling to that could help strengthen your faith while you are going through the storms.

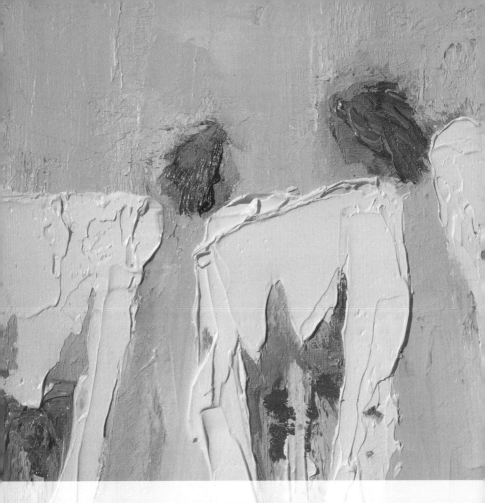

TWENTY-EIGHT

Follow

"Where you go I will go, and where you
stay I will stay. Your people will be my
people and your God my God."

RUTH 1:16

I want my children to follow in my footsteps—you know, the good ones, where I've been safe and responsible, where my path has been one of devotion, alongside Jesus. I don't, however, want them to follow me where I've gone wildly off course, chasing fears and doubts or being led by shiny objects and earthly rewards. My journey in following God these days is much more consistent, but still not perfect. I sometimes catch myself and wonder if I really want to go where the Lord is leading. Sometimes . . . I don't. And then I remember what it's like to be devoted, so there I go, one foot following the other.

Social media has really altered our definition of "following." Perhaps it has less to do with actually *following* and more to do with *observing*. Who do you say you are following when, in reality, you're merely observing?

SO THERE I GO, ONE FOOT FOLLOWING THE OTHER.

A certain level of devotion or commitment is required to follow someone or something. Who or what are you *actually* following?

Who in your life are you leading? Where are you leading them?

Aristotle said, "He who cannot be a good follower cannot be a good leader." So often we try to develop our leadership skills, but can you see how developing "followership" skills is just as important? Describe what that looks like.

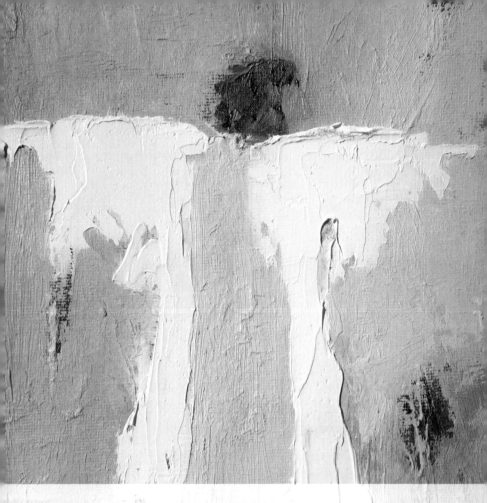

TWENTY-NINE

Pathway

*"Small is the gate and narrow the road that
leads to life, and only a few find it."*

MATTHEW 7:14

By now you may have noticed that a lot of these themes are related, with their messages intertwining and relying on each other, building on Christ's teachings and biblical principles. These pathways intersect, much like winding roads, and lead us to new places. In the Bible, roads serve as backdrops and examples for some of the most provocative and powerful stories. These roads and paths were where people congregated and were, therefore, the place where miracles occurred and people were forever changed. Often when we start on a path, we are not the same persons at the end, having been affected by the journey and the miracles along the way.

There is a narrow path that leads to life. What does this mean to you, especially in today's world?

God is our true north. He is our guide, asking us to follow Him. Can you sense His presence on your current path, and are you following Him completely?

Do you feel you're on a life-giving path now? If not, what might it take to find one?

In the space below, draw a simple road. Draw a small figure (this is you) and draw where you feel God is. At the end of the road, write what you feel is the ultimate destination. Then draw or write all the bumps in the road and roadside distractions that veer you from your destination. What do you notice?

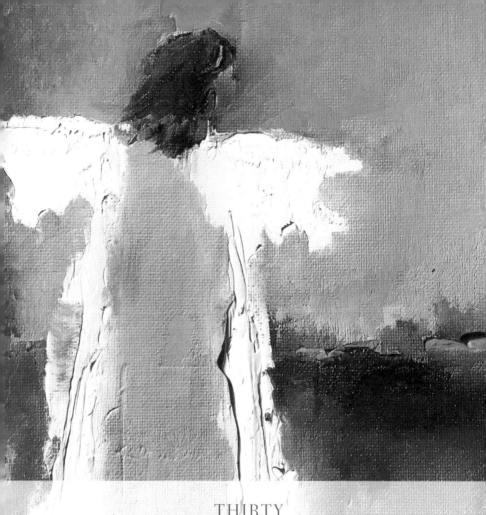

Goodness

*I remain confident of this: I will see the goodness
of the Lord in the land of the living.*

PSALM 27:13

The Bible is filled with promises of God's goodness, and I am certainly motivated by this myself. I want to receive *all* of His goodness, love, grace, and mercy, in all of their forms. I want spiritual goodness and material goodness. I want to experience the kind of goodness that restores my faith in humanity, along with the simple goodness of a delicious homemade chocolate chip cookie and everything in between. With such profound hope in the goodness of the Lord, I can rest in faith, knowing that even when things are not good, He always is.

What does the dictionary say *good* means?

The word *good* is one of those words that is used so widely it sometimes loses its meaning. What does *good* mean to you? What are all the ways you use it?

What not-so-good things are testing your spirit on a daily basis?

I WANT TO RECEIVE *ALL* OF HIS GOODNESS.

It's time to take another inventory to remind ourselves of all the ways God is good. List everything good that you can possibly think of. Fill the page on this one.

1. _____

2. _____

3. _____

4. _____

5. _____

6. _____

7. _____

8. _____

9. _____

10. _____

11. _____

12. _____

13. _____

14. _____

15. _____

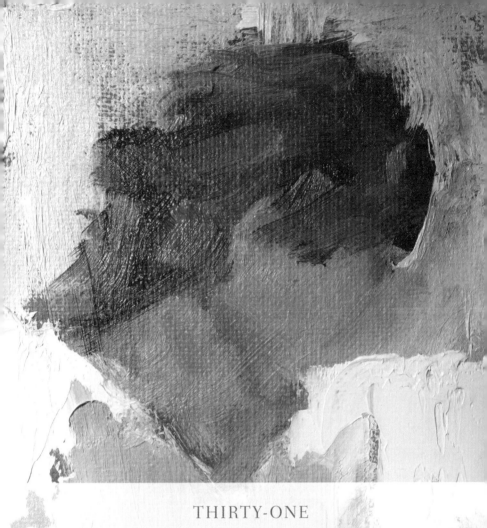

THIRTY-ONE

Scar

He heals the brokenhearted and
binds up their wounds.
PSALM 147:3

A builder once told me, "Anne, the more knots there are in the timber, the stronger the wood is." I found out that, technically, this is not a true statement. But I think of this idea every time I think of scars or look at one of my own. It's the perfect metaphor for taking something we deem ugly and shedding light on the goodness and beauty of it. Whether or not it's true for the timber, I've noticed that the more scars *we* have, the stronger *we* tend to be. This strength comes in many forms, and just as no two scars are exactly alike, your strength may look very different from mine, but that doesn't make it any less significant.

Which battle scars are you hiding? How have they shaped and strengthened you?

What kinds of victories do they represent?

What would it be like if you let the people in your life see
your scars—not the physical scars but the wounds that
have been embedded in the depths of your soul?

When you think of some of your scars and wounds, visible or invisible, can you trust God to turn these into something beautiful?

THE MORE SCARS *WE* HAVE, THE STRONGER *WE* TEND TO BE.

I will never forget watching a glass blower take shattered glass and remake the object into something even more beautiful. What kind of artistic expression might you use to embellish your scar?

Identity

Therefore, if anyone is in Christ,
the new creation has come: The
old has gone, the new is here!

2 CORINTHIANS 5:17

I've spent my whole life creating an identity for myself as an artist, wife, mother, friend, business owner, and leader—accomplishing one thing after another, and adding these labels to my well-crafted identity. However, there is only one identity that truly matters: daughter of the King. We are each a new creation, made in our heavenly Father's image. And while it's true that I am an artist, it's really just my way of serving and worshiping Him. Though I've had success as an artist, more and more, art is simply becoming my offering rather than my identity.

Think of some of the ways you identify yourself, all the things you call yourself. These could be adjectives to describe your character or the roles you play in life. List them below.

1. _____

2. _____

3. _____

4. _____

5. _____

6. _____

7. _____

8. _____

9. _____

10. _____

Which identity label do you wish you could peel off? Write it in the box below.

Write what you would put in its place.

Are you being called to take on a new identity? If you had to give this new identity a name, what would it be? Describe this person.

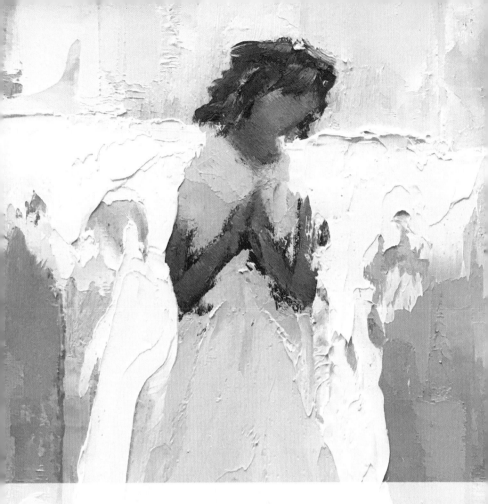

THIRTY-THREE

Shepherd

*Like a shepherd He will tend His flock,
in His arm He will gather the lambs and
carry them in the fold of His robe; He
will gently lead the nursing ewes.*

ISAIAH 40:11 NASB

Our Father in heaven loves us. As the Good Shepherd, He is always watching and leading us, steering us ultimately to greener and safer pastures. This doesn't mean the path to get there is always easy. In fact, God promises there will be struggles. Yet He comes alongside us, offering comfort and guidance along the way.

Just as we are part of Jesus' flock, we've been given a flock of our own to shepherd. Who has God given you charge of?

Who in your flock seems somehow lost? What can you do to help steer them back to a place that will protect and foster their growth?

What qualities does a good shepherd possess?

How could you improve your leadership and shepherding for those in your charge?

HE IS ALWAYS WATCHING
AND LEADING US.

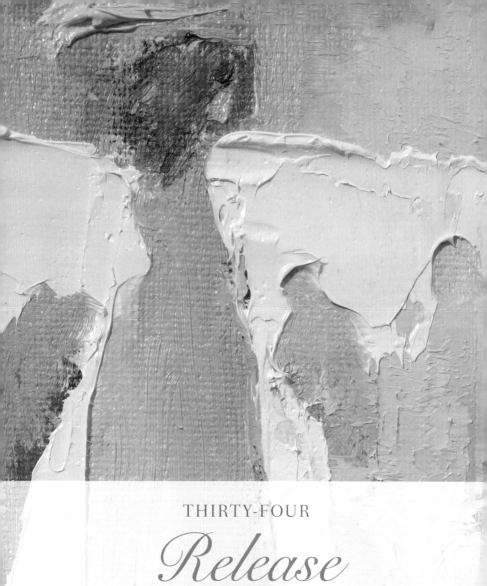

THIRTY-FOUR

Release

"So if the Son sets you free, you will be free indeed."
John 8:36

I can think of a number of times when I've achieved or found something so meaningful to me, only to then hear that still, small voice whisper, "Can you release this? Can you let go?" I've pretended not to hear it, for fear of losing whatever precious thing I was holding on to. I've even convinced myself it was my own thoughts making up that voice. But with the message comes a sense of *knowing*, and then I am given a choice to either surrender and obey or not. Here's the cool part: whenever I surrender and release that which I've held on to so tightly, God finds a way to replace it with something even better.

It's interesting to think that the things we're holding on to are actually holding on to us. What are you holding on to that God is asking you to release or that a nudge in your spirit is asking you to let go of?

How might you be released and freed as a result?

How do you know when it's God's voice urging you to
surrender something versus someone else's, including
your own?

> **"CAN YOU RELEASE THIS?
> CAN YOU LET GO?"**

What does freedom mean to you?

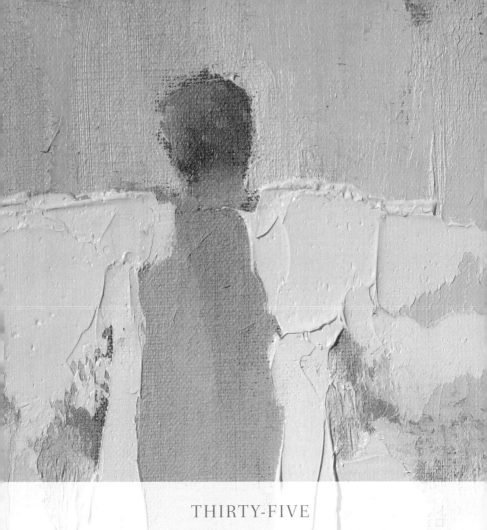

THIRTY-FIVE

Prayer

*Pray in the Spirit on all occasions with all kinds of
prayers and requests. With this in mind, be alert and
always keep on praying for all the Lord's people.*

EPHESIANS 6:18

For me, prayer is simply communicating with a living person in the form of Jesus. It's talking, sharing, listening, and spending time—much like other relationships in my life. So what makes prayer so special? Well, with Jesus, I'm able to trust Him completely. I'm always comforted by Him. He's never in a bad mood or too busy for me. I always leave His company feeling held, guided, and loved. I talk to Him at all times, in all situations, at all hours. As a result, I can hear Him more easily. His voice has become one I am quick to recognize and the one whose whisper can cut through any chaos.

Do you believe in the power of prayer? How do you feel when someone prays for you?

How would you describe your prayer life? Does prayer seem daunting or overwhelming? Or does it come naturally to you?

What's the most dramatic or miraculous thing you've seen or experienced as a result of prayer—either someone else's or your own?

Whether you're new to prayer or you're a prayer warrior, how can you deepen your prayer life?

> HIS VOICE . . . CAN CUT THROUGH ANY CHAOS.

List some ways to stay connected to a living God whose number one desire is to stay connected to His beloved.

1. _____

2. _____

3. _____

4. _____

5. _____

THIRTY-SIX

Entrust

Entrust your work to the LORD, and
your planning will succeed.
PROVERBS 16:3 ISV

To entrust means to commit to another—with confidence. If you know anything about me, you know how difficult this can be for me. I tend to want to do it all myself, though I know full well that's not part of what I'm called to do. One of my biggest lessons is not only surrendering and letting go, but then entrusting the person, the situation, the "thing" to someone else. It's allowing God to lead with His agenda. And it's not like I don't have good agendas—I do! However, His are always better. So I've had to learn to entrust my life, and the lives of others, to Him.

We have all been entrusted with something or someone. What all have you personally been entrusted with?

What are you refusing to give up and entrust to someone else, be it to another person or God Himself?

What's causing your need to control and unwillingness to allow someone else to step in to help?

What might happen if you let go and entrust God with your most precious and beloved person or possession?

IT'S ALLOWING GOD TO LEAD WITH HIS AGENDA.

Take a leap of faith today and pinpoint one person or situation you are willing to let go of, and describe it below. Watch and document how the Lord intervenes and takes care of the person or situation.

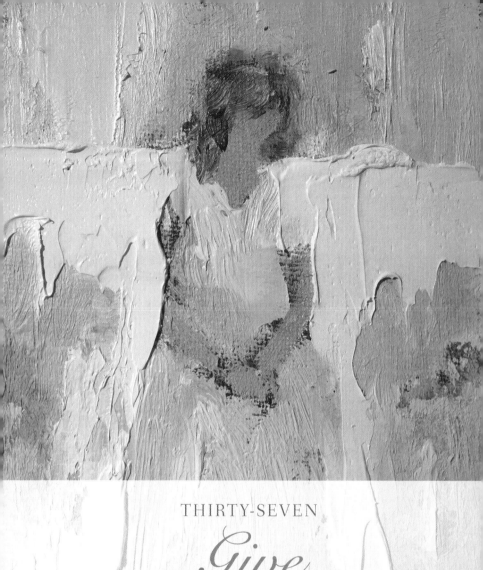

THIRTY-SEVEN

Give

*Each of you should give what you have decided
in your heart to give, not reluctantly or under
compulsion, for God loves a cheerful giver.*

2 CORINTHIANS 9:7

There's a story in Mark 14:3–9 about a woman who attended a dinner in Jesus' honor, hosted by Simon the Leper. The woman approached Jesus and offered her most precious possession to Him: an alabaster jar full of perfume. She broke it open and poured it out on her Lord, a beautiful picture of a generous gift. It wasn't long before she was scolded for carelessly wasting her goods instead of selling the perfume to help the poor. But Jesus didn't scold her. He was grateful for her generous gift. Sometimes we're called simply to offer a smile; other times we're called to give audaciously. He uses everything we give and increases it for His glory.

What is one of the most precious gifts you've ever received?

What's a gift that was precious to you that you offered to someone else?

In addition to presents, what are some other kinds of gifts to share with people?

What is something that you've been holding close and dear to your heart that you could offer to God? Write or draw it in this space.

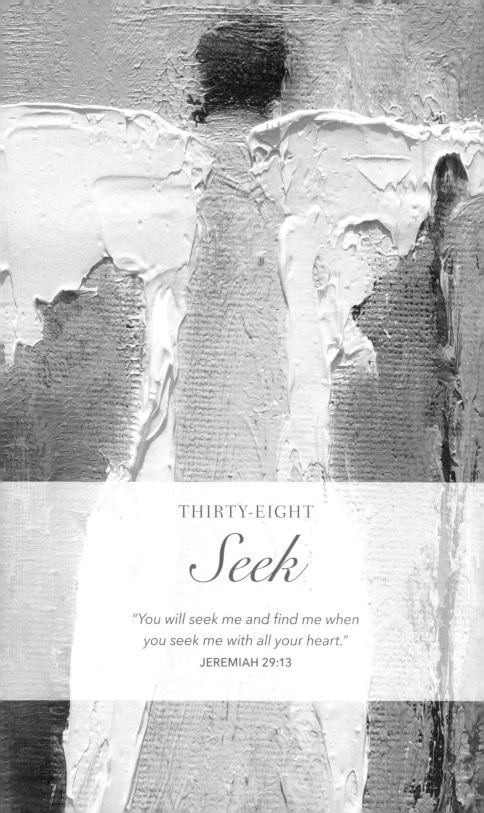

THIRTY-EIGHT

Seek

*"You will seek me and find me when
you seek me with all your heart."*

JEREMIAH 29:13

When we think of seeking, we often think of looking for and finding something. Maybe a lost item, a new item, a person. But it was through a very simple, humbling situation when my daughter lost a stuffed animal that I learned about seeking God *in* all things and *for* all things. Seeking Him means taking an active stance, being full of intention, and paying full attention to His guiding and leading. I'm learning to pray without ceasing for all things big and small, knowing that He will answer my prayers in His divine timing, and I want to be awake and present, able to seek and see these answered prayers as they show up.

What does it mean to "seek with all your heart"?

To seek means "to look for" or "to ask for." Given these definitions, what are you seeking in your life? List these here.

1. _____
2. _____
3. _____
4. _____
5. _____
6. _____
7. _____
8. _____
9. _____
10. _____

What is the one thing from the previous list that you're seeking the most?

> **SEEKING HIM MEANS TAKING AN ACTIVE STANCE.**

If it's possible to seek with 100 percent effort, what percentage do you feel you're using to seek this thing you most desire? What would make up the gap?

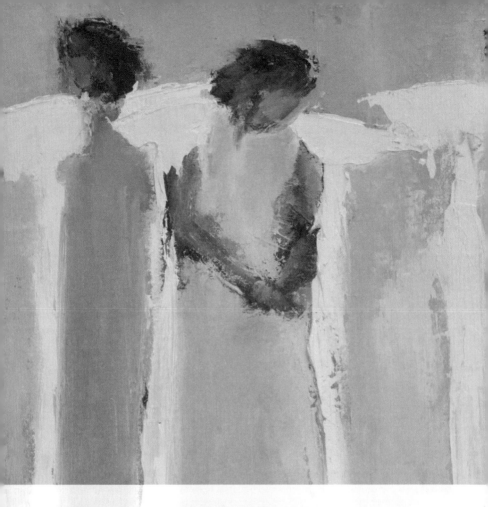

THIRTY-NINE

Forgive

Be kind and compassionate to one
another, forgiving each other, just
as in Christ God forgave you.

EPHESIANS 4:32

Forgiveness is perhaps one of the most difficult commands we've been given. When we've been wounded—either by word or deed—our feelings can seem impossible to navigate, let alone push past to find our way to the kind of freedom from pain that God promises us through the act of forgiveness. But how do we even begin? Where do we start when the hurt feels so deep? And what about the things we've done that need forgiveness? Whether you ask for forgiveness first or offer it, both asking and offering will work in tandem to soften your heart and allow healing to occur.

What are some of the hurts and anger you've refused to release? Are you ready to let them go?

Who can you forgive today?

1. _____
2. _____
3. _____
4. _____
5. _____

What would you like to ask forgiveness for? And from whom? List each below.

1. _____
2. _____
3. _____
4. _____
5. _____

FIND OUR WAY TO THE KIND OF FREEDOM FROM PAIN THAT GOD PROMISES US THROUGH THE ACT OF FORGIVENESS.

Let's clean house today. Take these things to God in prayer, thoughtfully and thoroughly. Include those who have wronged you and those you've wronged. When you're finished, write about your experience below.

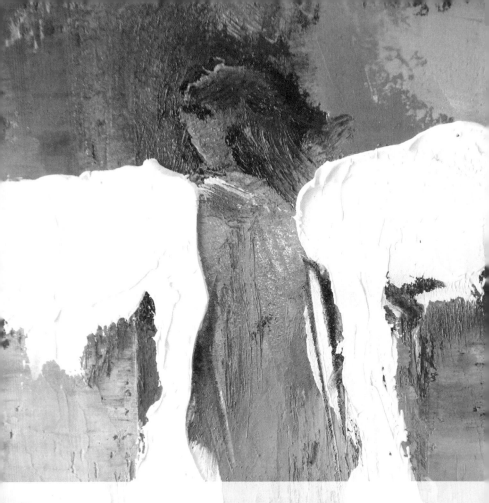

FORTY

Purpose

We know that for those who love
God all things work together for
good, for those who are called
according to his purpose.

ROMANS 8:28 ESV

Purpose has become a word charged with so much meaning, hasn't it? It's become big and grand and oversized, which is great. I think having a life's purpose calls us forth. But there's another kind of purpose that I don't want us to overlook, and that's the purpose of a divine appointment in any given moment, on any given day. The kind where you feel God calling you to act right now—to make that call, to say those words, to offer that forgiveness, to give that dollar, whatever it may be. That kind of purpose requires listening, listening, listening. Do you recognize God's voice when He prompts you?

What is one of the big purposes you feel your life is meant for?

What is a divine appointment that you can recall from your own life? What were the messages you received in order to accept that appointment?

How was your life—or someone else's—changed as a result?

DO YOU RECOGNIZE GOD'S VOICE WHEN HE PROMPTS YOU?

Think of all the future divine appointments just waiting for you. How can you train your spiritual ear to hear these calls?

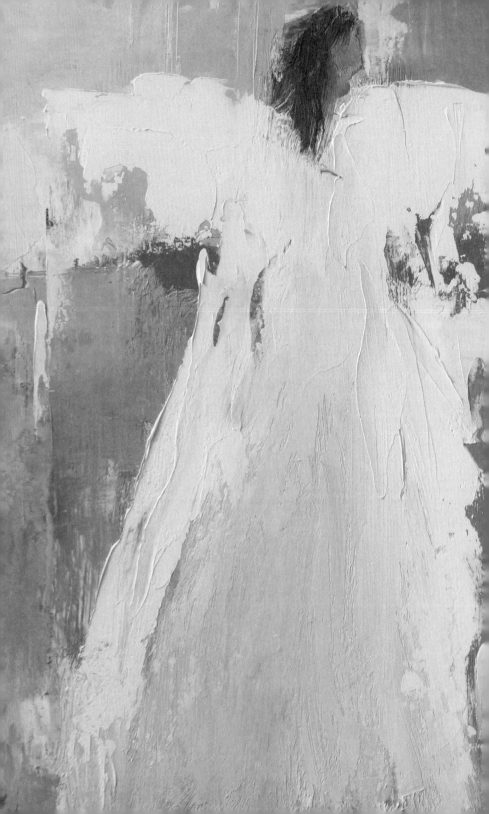

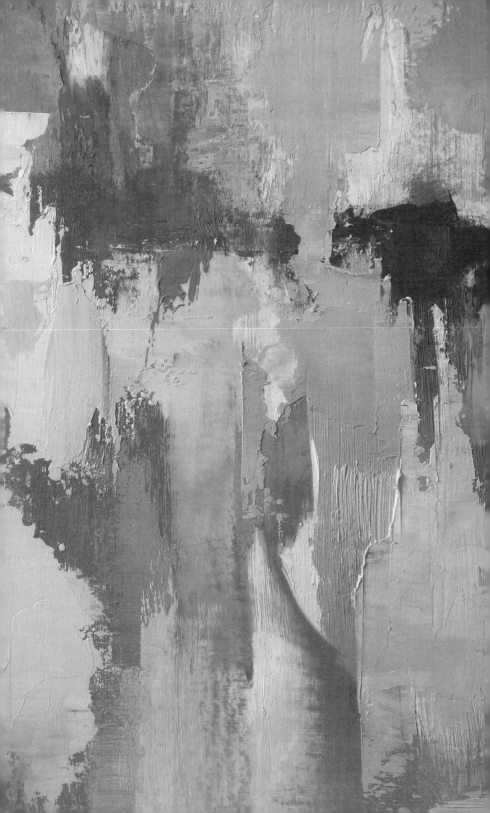

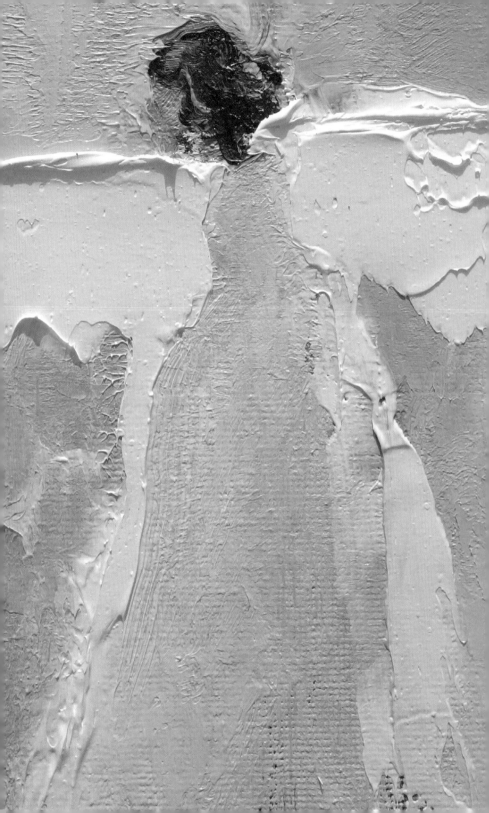

Acknowledgments

First of all, I am ever so grateful for everyone who purchased a copy of my first book, *Anne Neilson's Angels: Devotions and Art to Encourage, Refresh, and Inspire*. We had no idea that we would sell so many books in such a short time . . . which quickly sparked the interest to create this guided journal. My hope is that we continue to reach and bless millions of people, bringing hope and encouragement along the way. We are on our way to reach that goal, and, of course—with God's promises—He will do immeasurably more than we could ever ask or imagine, and He gets ALL the glory.

I also want to thank my amazing team at HarperCollins. Their support, their team, their vision, their guidance, and their designing have truly been a blessing as we put this little journal together.

Painting was a hobby for me back in 2003. I never knew that God would take hold of my gift and expand it the way He has over these twenty-one-plus years.

I want to thank my growing team at Anne Neilson Home and Anne Neilson Fine Art for all of your support along the way. People say all the time, "I don't know how you do all that you do,"

and it's because I have the most amazing team members who are the structure and foundation that support me as we grow. As I tell them, when we surrender what God has put into our hands, He will go before us and do something extraordinary. Let go and trust what He will do.

So I am letting go . . . giving God this new little guided journal . . . and trusting Him to get it into the hands of many. I am grateful for the journey. Thank *you* for being a part of it!

Credits

All images and artwork courtesy of Anne Neilson. © 2020 Anne Neilson

Page 10: © Savannah Dix

Page 13: © Savannah Dix

Page 186: © Savannah Dix

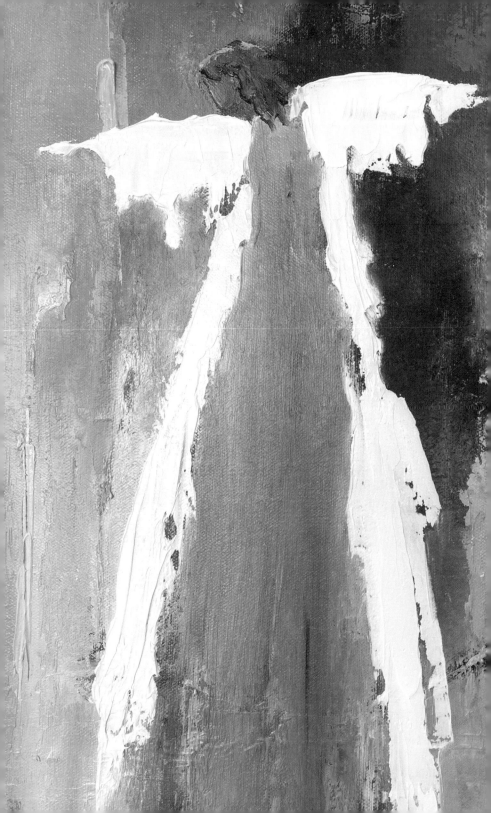

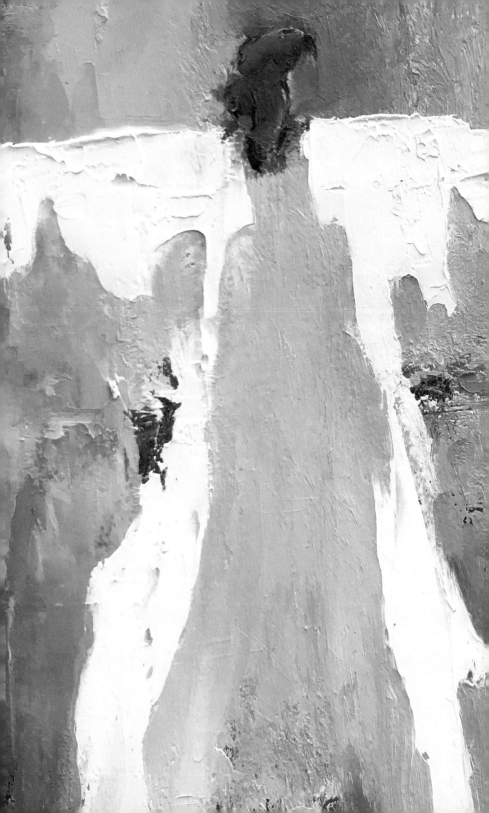

About the Author

A lifelong artist, Anne Neilson began painting with oils in 2003 and quickly became nationally renowned for her ethereal Angel Series. Neilson's paintings are inspiring reflections of her faith.

In 2012 Neilson self-published *Angels in our Midst*, her first of three coffee table books. Following its success, *Strokes of Compassion* and *Angels: The Collector's Edition* were released. The books follow her journey through the Angel Series, sharing inspirational and personal stories behind her paintings and the organizations she supports. Neilson also launched Anne Neilson Home—a growing collection of luxury home products including candles, notecards, scripture cards, prints, and journals. Her latest book, published by Thomas Nelson, *Anne Neilson's Angels: Devotions and Art to Encourage, Refresh, and Inspire* sold over 50,000 copies in the first two months. It explores forty words, each accompanied by an angel painting, a thoughtful definition, Scripture, prayers, and reflections from Anne's life.

Neilson also owns Anne Neilson Fine Art, a gallery located in Charlotte, North Carolina. Representing more than fifty talented artists from around the world, the gallery is dedicated to being a lighthouse, illuminating the work of both emerging and established artists.

As a wife, mother of four, artist, author, and philanthropist, Anne paints and creates with passion and purpose, always giving back to others by contributing to local, national, and international charitable organizations.

Learn more about Anne Neilson Home and her gallery, Anne Neilson Fine Art, at anneneilsonhome.com and anneneilsonfineart.com.

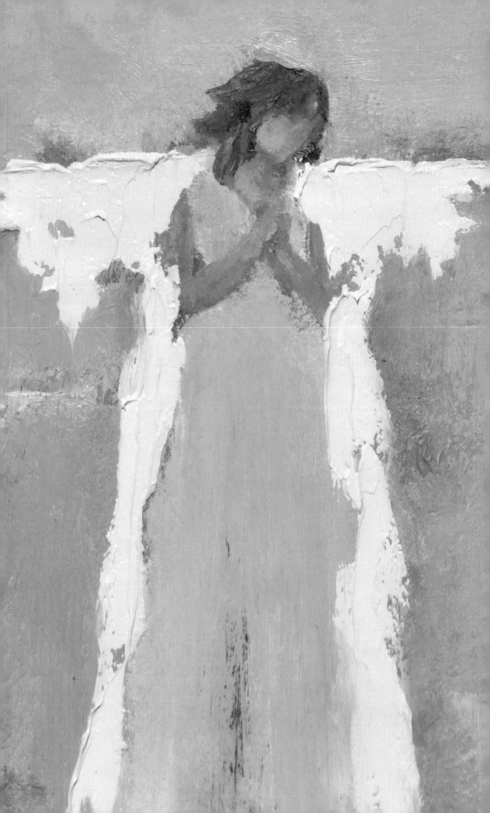

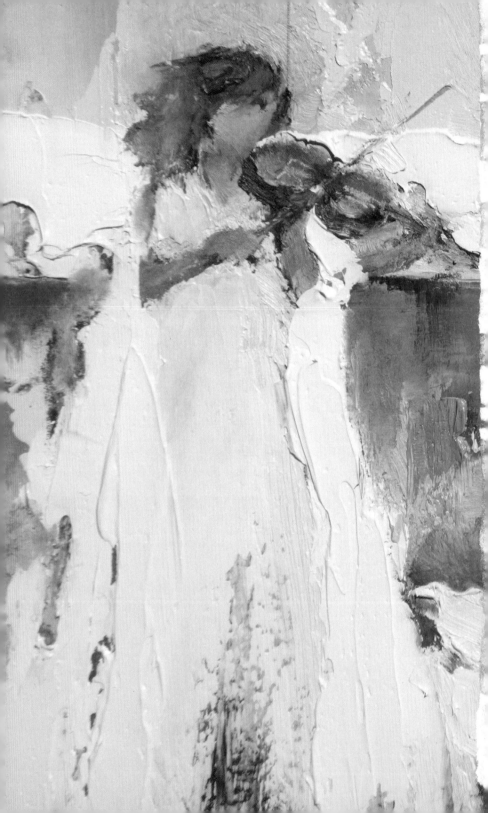